Drawing MOVIE MONSTERS Step-by-Step

Drawing KING KONG

Greg Roza

WINDMILL
BOOKS ™

New York

Published in 2011 by Windmill Books, LLC
303 Park Avenue South, Suite # 1280, New York, NY 10010-3657

CREDITS:
Edited by: Jennifer Way
Book Design: Julio Gil
Art by Planman, Ltd.

Photo Credits: Cover, pp. 6, 8, 12, 16 Everett Collection; pp. 4, 5 Shutterstock.com; p. 10 © Universal/courtesy Everett Collection; p. 14 RKO Radio Pictures Inc./Photofest © RKO Radio Pictures Inc.; p. 18 © DeLaurentiis Entertainment Group/courtesy Everett Collection; p. 20 © Paramount Pictures/courtesy Everett Collection.

Library of Congress Cataloging-in-Publication Data

Roza, Greg.
 Drawing King Kong / by Greg Roza.
 p. cm. — (Drawing movie monsters step-by-step)
 Includes index.
 ISBN 978-1-61533-016-4 (library binding) — ISBN 978-1-61533-023-2 (pbk.) —
 ISBN 978-1-61533-024-9 (6-pack)
 1. Monsters in art. 2. King Kong (Fictitious character) in art. 3. Drawing—Technique.
 I. Title.
 NC825.M6R695 2011
 743'.87—dc22
 2010006166

Manufactured in the United States of America

For more great fiction and nonfiction, go to www.windmillbooks.com.

CPSIA Compliance Information: Batch #S10W: For further information contact Windmill Books, New York, New York at 1-866-478-0556.

Contents

What's 50 feet (15.2 m) tall, really hairy, and really, *really* angry? It's a giant gorilla named King Kong! King Kong is a movie monster that has been scaring fans since he appeared in his first movie in 1933.

King Kong was created by Merian C. Cooper. Cooper was a pilot during World War I. He searched the world for **adventure**. He also liked writing and making movies.

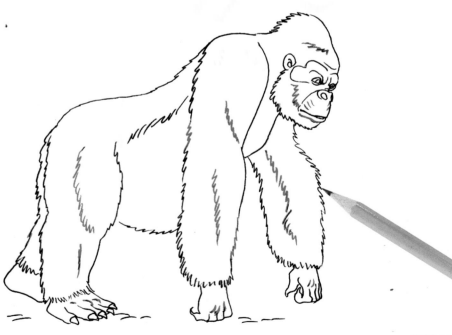

PENCIL

YOU WILL NEED THE FOLLOWING SUPPLIES:

ERASER

PAPER

RULER

COLORED PENCILS

MARKER

Lost Worlds

King Kong was **inspired** by "lost world" stories of the early 1900s. These were stories about the discovery of places that seemed like they were from a time long ago.

Writers like Arthur Conan Doyle and Edgar Rice Burroughs made these stories very popular.

Many of the lost world stories included ancient animals, such as dinosaurs. These giant animals inspired Merian C. Cooper to create a giant gorilla named King Kong.

Uh oh! King Kong is ready to attack! But first, let's try drawing him.

STEP 1
Draw an oval for the face. Add the outline of the body.

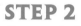

STEP 2
Draw eight ovals to guide you in drawing the arms and legs. Add lines to form the shoulders.

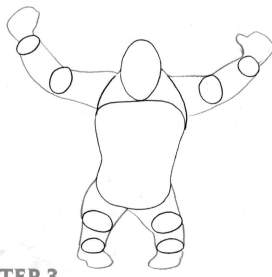

STEP 3
Join the ovals with lines to form the arms and legs. Add the outlines of the hands and feet.

STEP 4
Draw the fingers and the toes. Add a rectangular shape to the chest. Erase extra lines.

STEP 5
Add the outlines of the facial features. Draw the claws and the fur. Erase the guides.

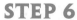

STEP 6
Add details to the facial features. Add more fur. Erase extra lines. Now color your drawing.

Off to Skull Island

In the 1933 movie *King Kong*, Fay Wray plays Ann, a beautiful young actress. Ann is looking for adventure. She joins a film crew that is going to Skull Island in the Indian Ocean to make a movie.

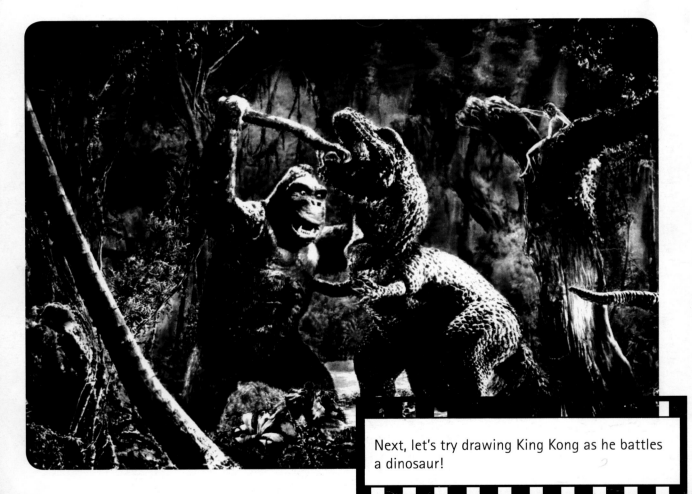

Next, let's try drawing King Kong as he battles a dinosaur!

Things take a bad turn as Ann is **kidnapped** by natives of Skull Island. They tie her up and give her to King Kong! The giant gorilla falls in love with her.

STEP 1

Draw an oval for each creature's head. Add the outlines of their bodies.

STEP 4

Draw the outlines of the faces and the hands. Add a shape for King Kong's chest. Draw the stick in King Kong's hand. Add the outline of the grass and bushes.

STEP 2

Add guide shapes as shown. Add lines to join the heads to the bodies.

STEP 5

Add the facial features, claws, and fur. Add details to the bushes. Erase the guide shapes.

STEP 3

Join the guide shapes using lines to form the arms, legs, and tail.

STEP 6

Add details to the faces and the rest of the scene. Draw scales, teeth, and fur. Erase extra lines.

Kong Comes to America

In the 1933 film *King Kong*, the filmmakers rescue Ann and capture King Kong. They take the monster from Skull Island to New York City.

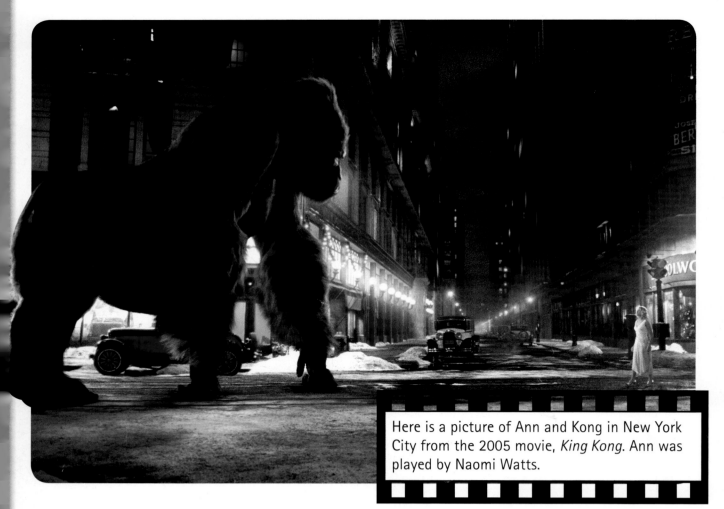

Here is a picture of Ann and Kong in New York City from the 2005 movie, *King Kong*. Ann was played by Naomi Watts.

King Kong then escapes and kidnaps Ann again! He climbs to the top of the Empire State Building with her. Airplanes attack the monster until he falls to his death. But don't worry, Ann makes it down safely!

STEP 1
Draw an oval for the head. Add the outline of the body.

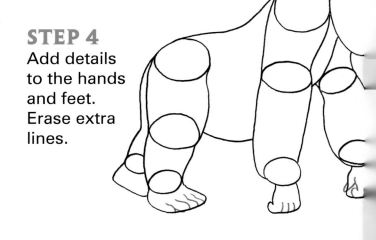

STEP 4
Add details to the hands and feet. Erase extra lines.

STEP 2
Draw round shapes around the body. These will guide you in drawing the arms and legs.

STEP 5
Draw the facial features. Add the claws and the fur. Erase the guide shapes.

STEP 3
Join the guide shapes to form the arms and legs. Add lines for the neck, hands, and feet.

STEP 6
Add details to the face and the fur. Erase extra lines.

Bringing Kong to Life

The people who made *King Kong* in 1933 used a **special effect** called stop-motion photography. First, a photographer takes a picture of a model of a gorilla. Next, the model is moved very slightly, and another picture is taken.

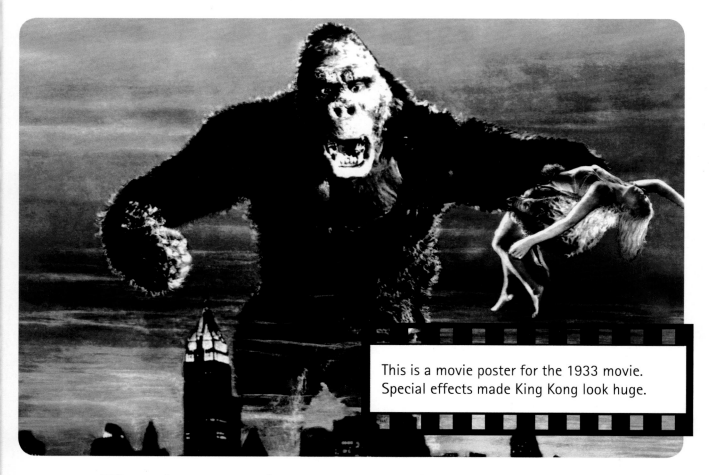

This is a movie poster for the 1933 movie. Special effects made King Kong look huge.

The photographer repeats this process over and over again. The pictures are shown one after another so the gorilla looks like it is moving by itself!

STEP 1
Draw an oval for the head. Add the outline of the body.

STEP 2
Draw guide shapes around the body.

STEP 3
Draw lines to join the guides and form the arms and legs. Begin to draw the hands.

STEP 4
Add fingers to the hands. Draw a woman in King Kong's left hand. Draw the buildings.

STEP 5
Add fur, claws, and other details to King Kong and Ann. Add lines to the buildings. Erase the guide shapes.

STEP 6
Add the final details to King Kong and Ann. Add windows and other details to the buildings. Erase extra lines.

13

Classic Movie Monster

Monster movie fans loved the 1933 **version** of *King Kong*. It was a very scary movie for its time, and **horror** movie fans loved to be scared!

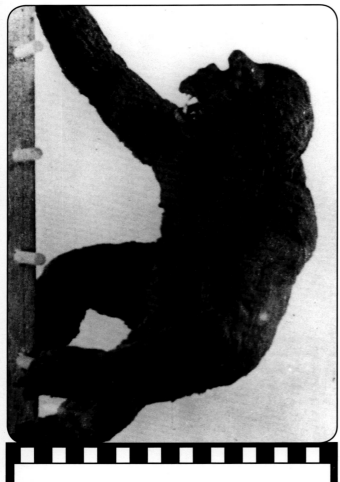

Let's try drawing Kong as he climbs up the side of a building.

In the 1930s, *King Kong* did not win any movie awards. Since that time, however, it has won many awards for its special effects and its importance as a film. Even today it is considered one of the best movies ever made.

STEP 1

Draw two round shapes for the head and the body.

STEP 2

Add smaller circles and ovals to use as guides for the arms and legs.

STEP 3

Use the guide shapes to draw the arms and legs. Begin the hands and feet. Add a line for the building.

STEP 4

Draw the outline of the chest. Add the outlines of the face, leg, fingers, and toes.

STEP 5

Draw the claws and the facial features. Add some fur. Add details to the building. Erase the guide shapes.

STEP 6

Finish your drawing by adding details to the facial features, the building, and the fur. Erase extra lines.

King Kong Returns

Filmmakers made more movies about King Kong. In *The Son of Kong*, a man from the first movie returns to Skull Island in search of treasure. He meets Kong's son, who is much smaller. Kong's son saves the main characters from a giant bear!

The original King Kong movie was in black and white. This image from the 1933 movie has had color added to it!

In 1962, King Kong battled another famous movie monster in *King Kong vs. Godzilla*. American filmmakers remade *King Kong* in 1976. Jessica Lange played the part that Fay Wray played in the 1933 film.

STEP 1

Draw an oval for the head. Add a larger shape for the outline of the body.

STEP 2

Add ovals around the body as shown. Connect the head to the body with a curved line.

STEP 3

Draw lines to connect the ovals to form the arms and legs. Add the outlines of the hands and the feet.

STEP 4

Add a curved line to the top of the head. Add lines for the fingers and toes. Draw the outlines of the airplanes and the building.

STEP 5

Begin to add facial features, claws, and fur. Add details to the airplanes and the building. Erase the guide shapes.

STEP 6

Finish your drawing by adding more details to the face, fur, airplanes, and building. Erase extra lines. Finish your drawing by adding color.

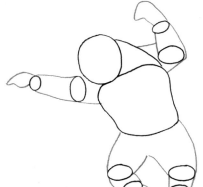

The New King Kong

The most recent movie to feature the giant gorilla was the 2005 movie *King Kong*. It tells the same story as the 1933 movie. However, this time filmmakers used computers to create a more realistic-looking King Kong. This made the giant monster scarier than ever before!

The new King Kong was also smarter. He used **sign language** to talk to Ann, who was played by Naomi Watts.

Quick, let's draw King Kong before he breaks those chains!

STEP 1
Draw an oval for the head. Add a large shape for the outline of the body.

STEP 2
Add small round shapes around the body.

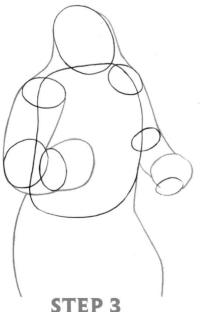

STEP 3
Draw curved lines to form the shoulders, arms, and lower body.

STEP 4
Add fur to the face and body. Draw the fingers and an ear. Add the chains that hold King Kong's wrists.

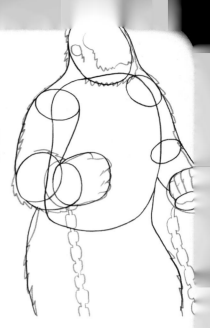

STEP 5
Draw the facial features and the outline of the chest. Add more fur. Finish drawing the chains. Erase round guides.

STEP 6
Add the teeth. Finish the facial features and the fur. Erase extra lines.

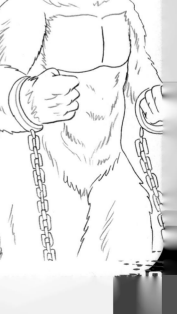

A Memorable Monster

The success of the 2005 movie shows that King Kong is still as popular as ever. But the giant gorilla is more than a movie star. His likeness has been featured in books, cartoons, comics, video games, and television shows. You might even find a few King Kong toys.

Today, King Kong is one of the most memorable movie monsters of all time. Keep practicing, and soon you'll be able to draw your own King Kong.

Kong beats his chest and lets out a mighty roar! We'll try drawing him from a safe hiding spot.

STEP 1

Draw an oval for the head.
Draw the outline of the
body below the oval.

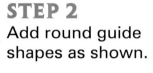

STEP 2

Add round guide
shapes as shown.

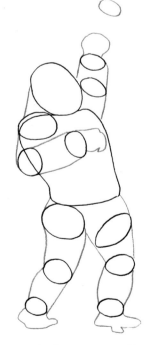

STEP 3

Join the round shapes to form
the arms and legs. Add the
outlines of the hands and feet.

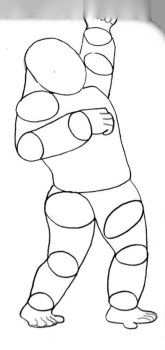

STEP 4

Draw King Kong's
fingers and toes.

STEP 5

Add lines to the
chest. Draw the facial
features. Give King
Kong claws and fur.
Erase the guides.

STEP 6

Add details to the
facial features and
the fur. Draw the
ground. Erase
extra lines. Color
your drawing.

- Several scenes were taken out of the original 1933 *King Kong* because they were believed to be too scary. One scene featured a giant man-eating spider!

- For the 1933 movie, filmmakers created a giant King Kong head and two giant King Kong hands. They were used for close-up shots.

- Filmmakers spent $500,000 to make *King Kong* in 1933. Most movies at the time cost much less money.

- In 2005, the remake of *King Kong* cost $207 million to make. At the time, this was the most money ever spent on a movie!

Glossary

ADVENTURE (ed-VEN-chur) An unusual or exciting thing to do.

HORROR (HOR-ur) Something that makes people feel shock or fear.

INSPIRED (in-SPYRD) To have moved someone to do something.

KIDNAP (KID-nap) To take a person away by force.

SIGN LANGUAGE (SYN LANG-wij) A language in which hand motions stand for words or ideas.

SPECIAL EFFECTS (SPEH-shul uh-FEKTS) Tricks in moviemaking that make scenes that are fake look real.

VERSION (VER-zhun) A thing that is different from something else, or that has different forms.

Read More

Emberley, Ed. *Ed Emberley's Drawing Book of Halloween*. New York: Little, Brown, 2006.

Tallerico, Tony. *Monsters: A Step-by-Step Guide for the Aspiring Monster-Maker*. Mineola, NY: Dover Publications, 2010.

Woog, Adam. *King Kong*. Farmington Hills, MI: KidHaven Press, 2006.

Index

For Web resources related to the subject of this book, go to:
www.windmillbooks.com/weblinks and select this book's title.